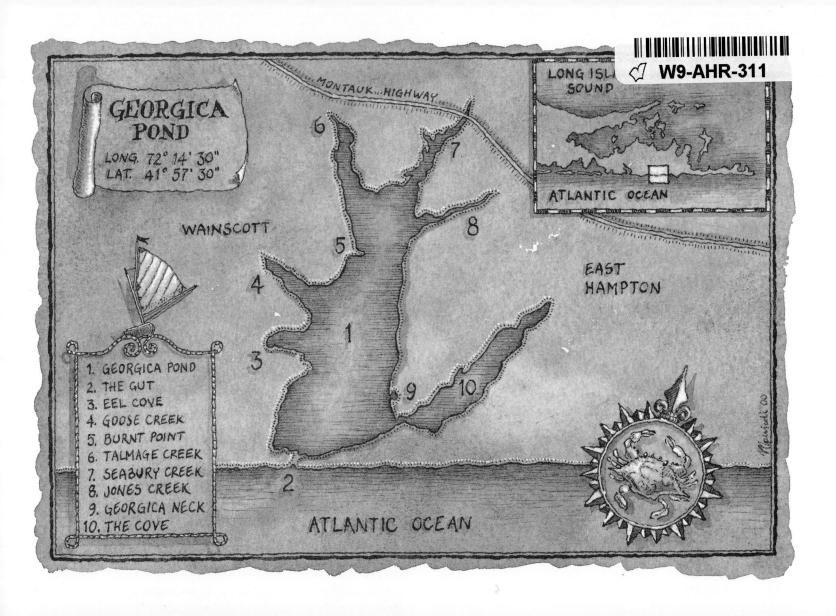

GEORGICA POND

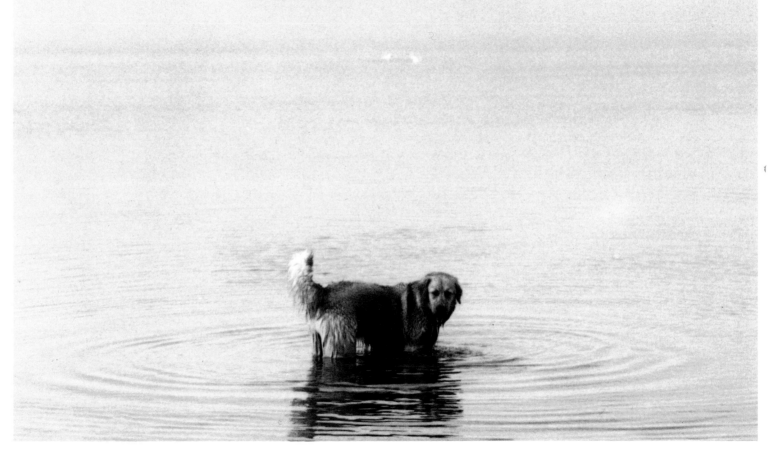

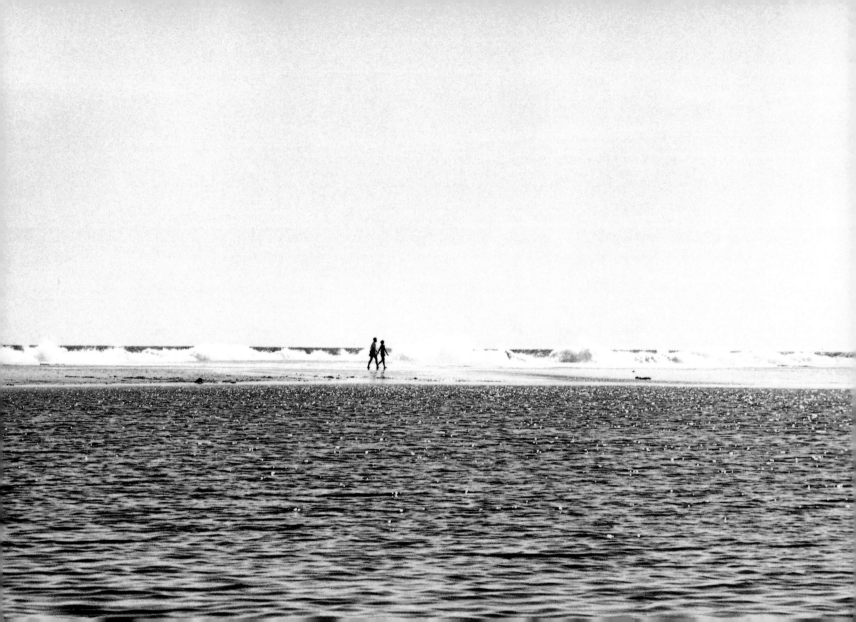

GEORGICA POND

Photographs by Priscilla Rattazzi

WITH ESSAYS BY

Robert Benton, Eleanore Kennedy, Kelly Klein, and Donald Petrie

CALLAWAY · NEW YORK

2000

To Chris, Maxi, Andrea, and Sasha

CONTENTS

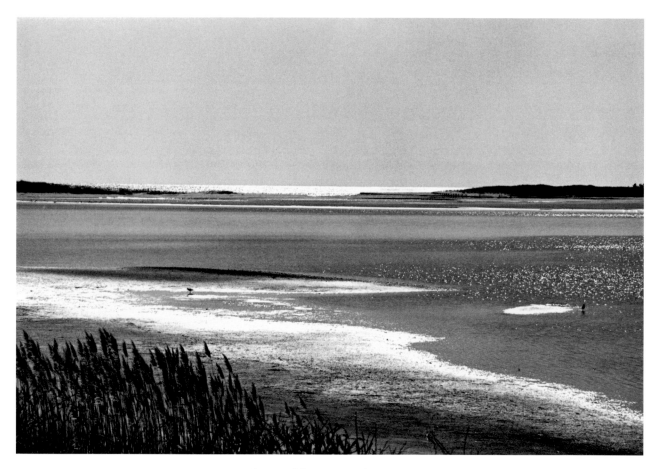

A view of the gut in early spring

PREFACE

No matter what I am doing when I am at home, I find myself constantly glancing at the view. I look at the pond. Then, to the south, I see the beach, and behind it, the ocean, glimmering in the distance. The combination of the pond, beach, ocean, and sky are an irresistible visual magnet. I find it difficult not to keep staring in the direction of the gut.

Where the sky meets the ocean, I like to imagine the curvature of the earth. The direction is southeast, and if I were to bear slightly left and keep going down that imaginary line, the coast of Europe would appear a few thousand miles later.

Over the years, I have watched major events happen on Georgica Pond—Hurricane Bob, the blizzard of '96, and President Clinton approaching on Marine One—but it is the minor happenings that make Georgica Pond so special: the ospreys diving for fish, from dawn until dusk, from April until August; the swans, moving elegantly up and down along the shore, never less than a dozen at a time, from early spring through early winter; the sailing races, always at three o'clock, every Saturday afternoon, in July and August.

I have watched the seasons come and go on Georgica Pond for ten years now. Whether it is spring, summer, fall, or winter, we are blessed with a view that has brought enormous happiness to our family and that has clearly inspired me.

Summer is our favorite season on Georgica Pond, as it is then that we are able to use it as a waterway. When the weather is good, the gut becomes a destination. The pond links our family to a community of friends who live in Wainscott, on the west side.

The beach is our meeting point. Getting there is half the fun. Some of us walk, some bicycle, and some come by boat. I like to sail. Depending on the direction and strength of the wind, the journey can take us anywhere from five minutes to half an hour. The less time it takes, the happier the children are. "Are we there yet?" is a constant refrain on sailing trips on the pond too.

Once we disembark, the grown-ups sit on the beach, catching up, while our children, depending on their age, either swim in the ocean or chase minnows in the pond. The ocean lies at our feet, noisy and somewhat terrifying. The pond lies behind us, quiet and safe.

It's a perfect spot to sit between the two. It's just like life . . .

Priscilla Rattazzi

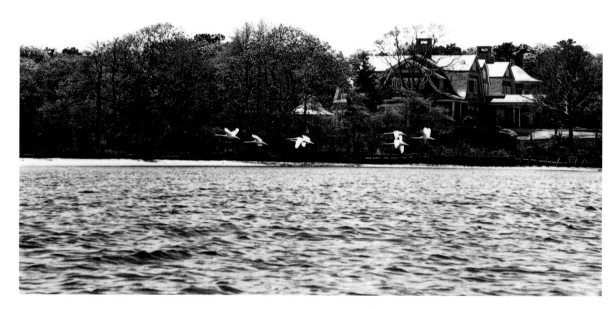

Swans flying over Burnt Point

SPRING

by Donald Petrie

IN THE NORTHERN HEMISPHERE, spring is a time when the multitude of species are sprouting, budding, blooming, pollinating, spawning, migrating, and, above all, mating. But on Georgica Pond, it is the time of annual combat between two great forces: the wind and the tide.

To grasp this struggle, one must first understand that Georgica Pond was created as a glacial river thirteen millennia ago. Its role was to carry the waters of a melting glacier down to the sea, which at that time was three miles farther out than it is now. Over all the time since, the river has run continuously through the sands descending from the northern hills, into the pond, and out again through the porous silt at the southern end, which we call the beach or bar.

When the gut of the bar is opened, usually by the Town Trustees, the water flows rapidly, not only outwardly but also inwardly, twice a day, as the ocean tide rises and falls above and below the pond level. This motion moves about a hundred million gallons of water with each tide. The force of this twice-daily flushing carries along everything that is loose, including sand and driftwood—as well as the migratory finfish and shellfish that come to spawn in the brackish waters of the pond. The total effect is that Georgica is kept empty, displaying acres of sandbars and a water elevation just above sea level. Left to its own devices, the tidal force would sustain the pond as an estuary open to the sea forever.

But the force of the tide is not alone. Struggling against it are the ocean winds, fresh and frequent in the spring. As the winds shift from east to west and back, they generate vigorous waves that carry a river of sand back and forth across the mouth of the gut. These wind-driven waves struggle each day to pinch off the open gut and end the outflow of water. They seek to deposit their sand across the gut and let the pond rise to its summer elevation, about the height of a person above sea level. The struggle is a daily comedy readily visible to any observer. Pond people—sailors, rowers, baymen, property owners—worry every year that the gut may not close and the summer pleasures of the pond will be denied.

But it never happens. The wind has always won the contest, sometimes, again, with a little help from the Town Trustees. By mid-June, the gut is closed, and the summer season flourishes until autumn arrives, and the pond is opened once more to prepare for the next annual cycle.

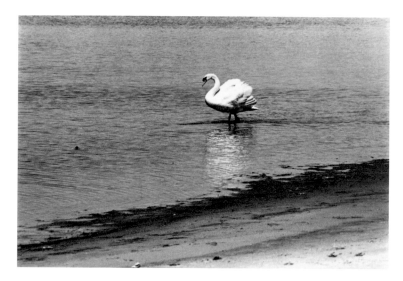

A cranky swan

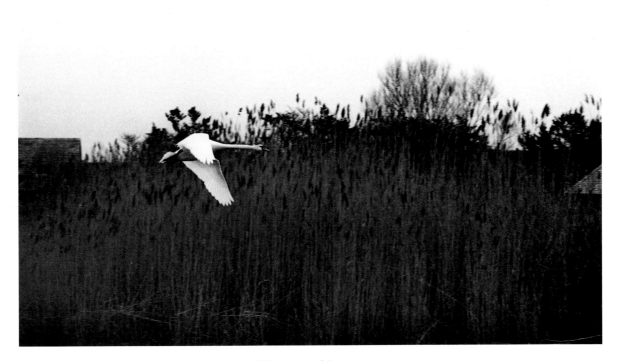

Flying out of the cove

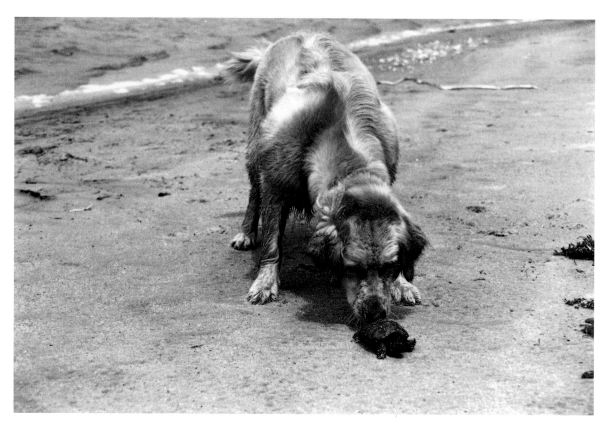

Luna and a baby snapping turtle

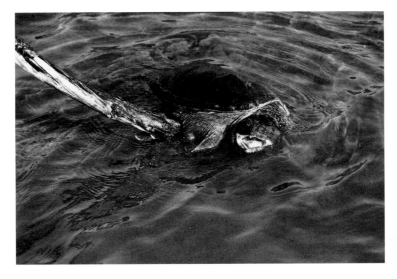

A gentle nudge

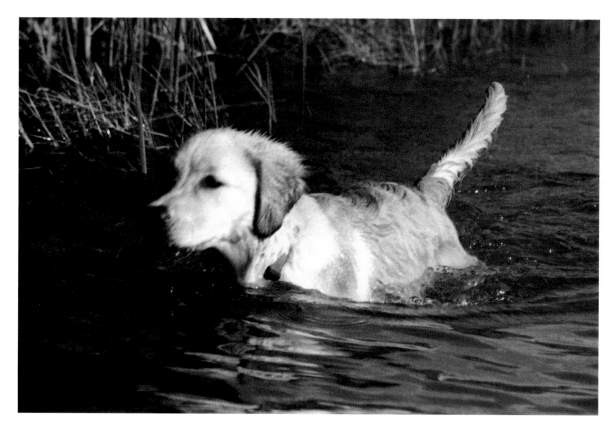

Water puppy

Please throw me the ball

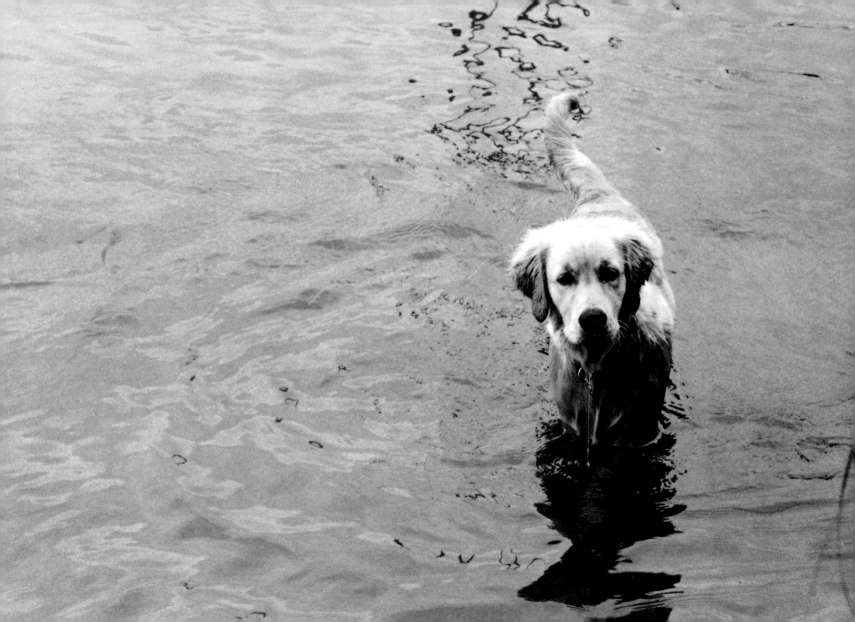

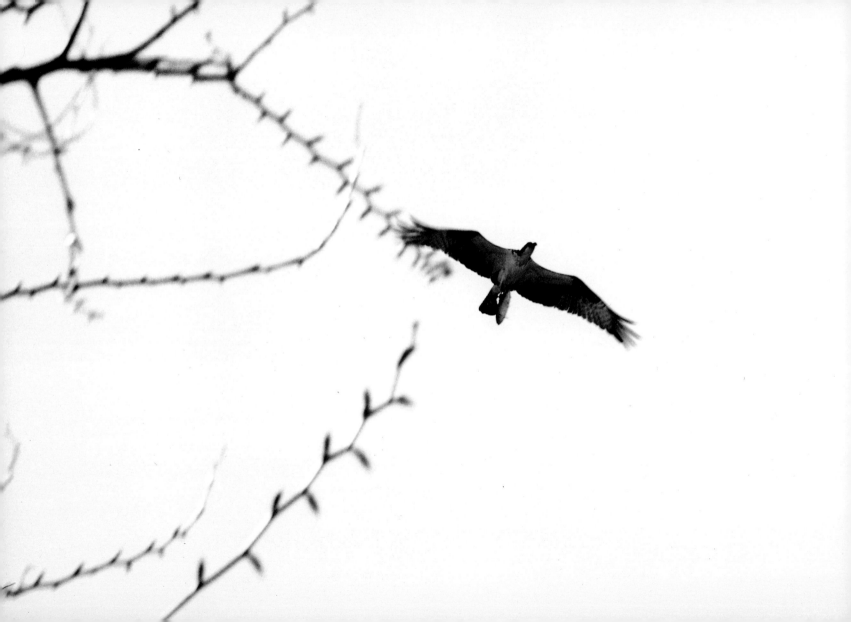

Osprey with fish

Digging the trench

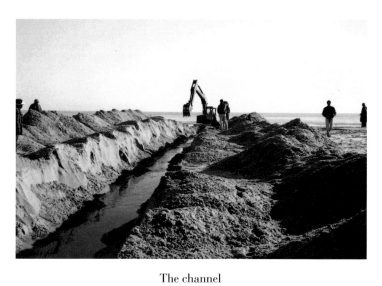

The channel

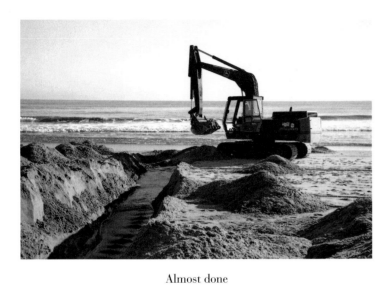

Almost done

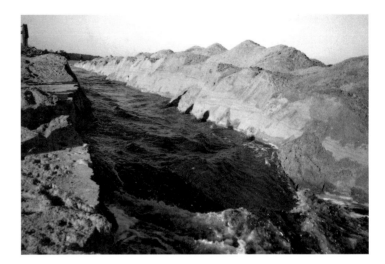

The flow

Swans in the early morning light

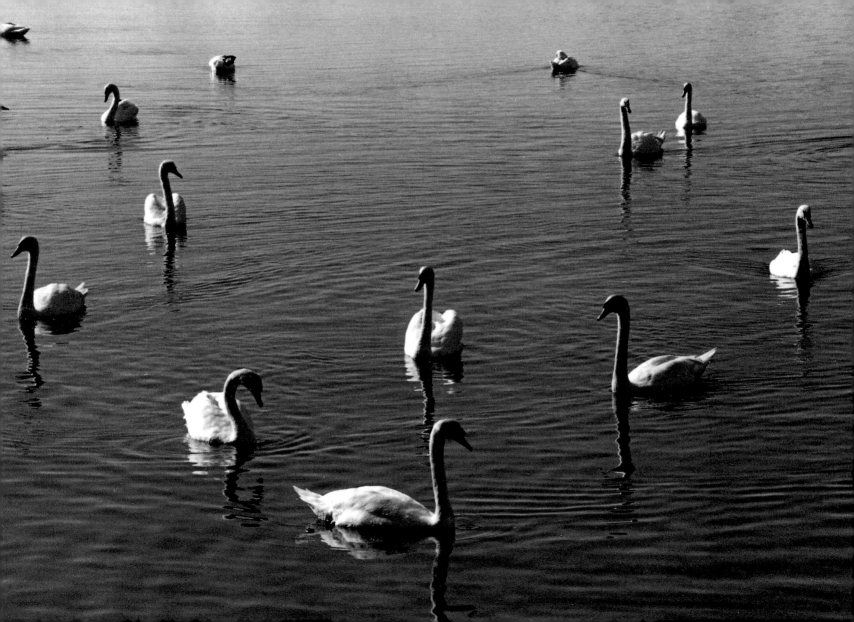

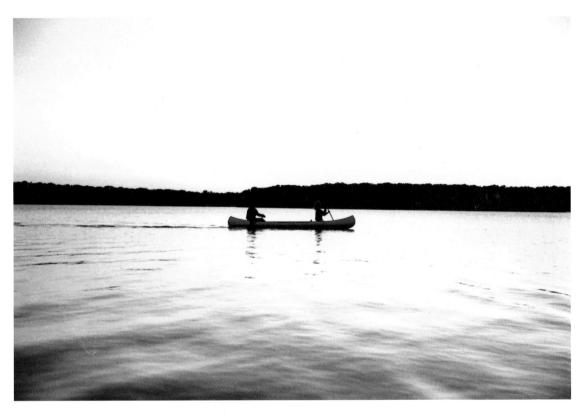

Heading home at sunset

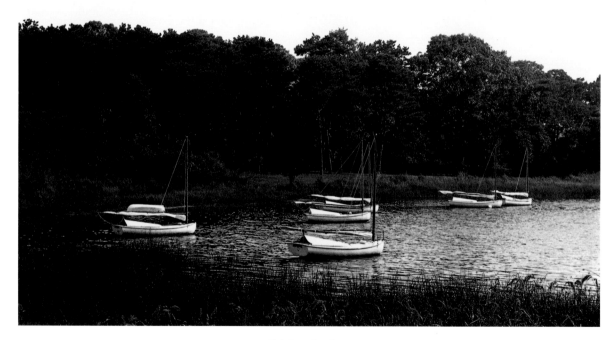

Eel Cove harbor

SUMMER

by Eleanore Kennedy

MY FAMILY has spent the last twenty-five summers on Georgica Pond. Memories of life on the pond come in rushes. I can see our daughter's first solo crossing in her sailboat at age twelve, with her best friend shouting encouragement from the east side. I remember canoeing to dinner with friends, as well as watching the Georgica sailboat races from Bromley Point each August, while enjoying Essie's tea sandwiches and lemonade on the lawn, with the cat boats on the wing, gliding on the wind. I remember rowing a dory with my husband against a strong wind that was constantly repainting the pond's surface and reflecting our insignificance in nature's sway.

Beneath its shimmer, the summer pond teems with all manner of shellfish and finfish. Children have always known that a stringed chicken leg will be grasped by blue crabs, in turn grabbed by children squealing with glee. How safe we mothers felt with our little children playing off to the right in the warm waters, giggling at the minnows at their tiny tanned feet. How bittersweet some years later to watch them as teenagers, off to our left, as they skimmed, boogied, bodyboarded—and surfboarded—the Atlantic's waves. No more wrapping them in summer towels. They have their own spot near the dread jetties to the east.

I think of the summer sun gilding the pond almost white with heat. And when "Sometimes too hot the eye of heaven shines," shade from the odd cloud or beach umbrella is welcomed. Little else shades us around the pond. Late in the afternoon, steady southwesterlies stir up beach grasses and dusty miller, black pines, bayberry, and *rosa rugosa*, cooking them together into "summer's ripening breath." We cook, too: summer socials of family and community, barbecues, marshmallow roasts, and sing-alongs by the fire at our Monday night picnics. Every summer there is an elegant birthday dinner, ladies only, for my dear friend on that narrow strand of sand.

Deep in January I can close my eyes and summon up those glorious days of summer on Georgica Pond. With my best friends. Talking ideas, facts, and gossip. Our children playing, circling around us in the warm, clean sand pocked by the ugly ruts of unnecessary trucks. Visits from our husbands. All accompanied by food, drink, and loyal dogs.

My mother told us, "Our hand of God is Georgica Pond. Five fingerling streams feeding the palm of this sea-washed hand." The osprey soars high above and peers beneath the pond's skin. This is where our children are raised, friendships nurtured, and milestones celebrated. All is in harmony.

These are the best times of our lives.

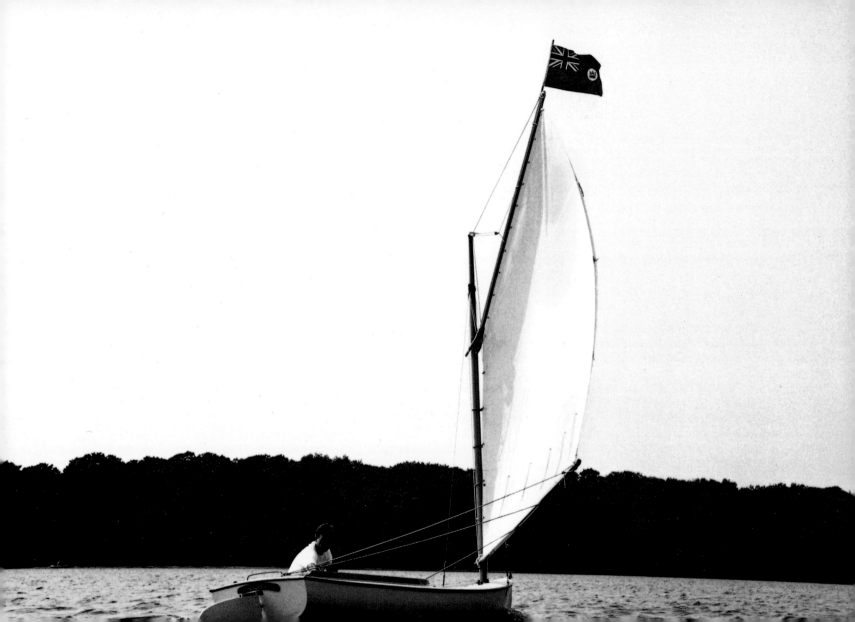

Boathouse at sunset

Heading for the finish line

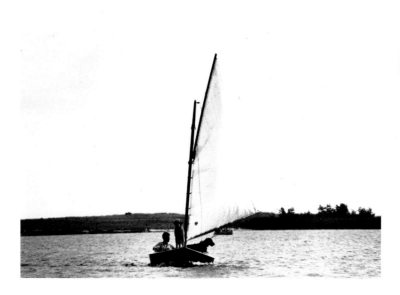

Tow me home

A dog's life

Passing Kilkare

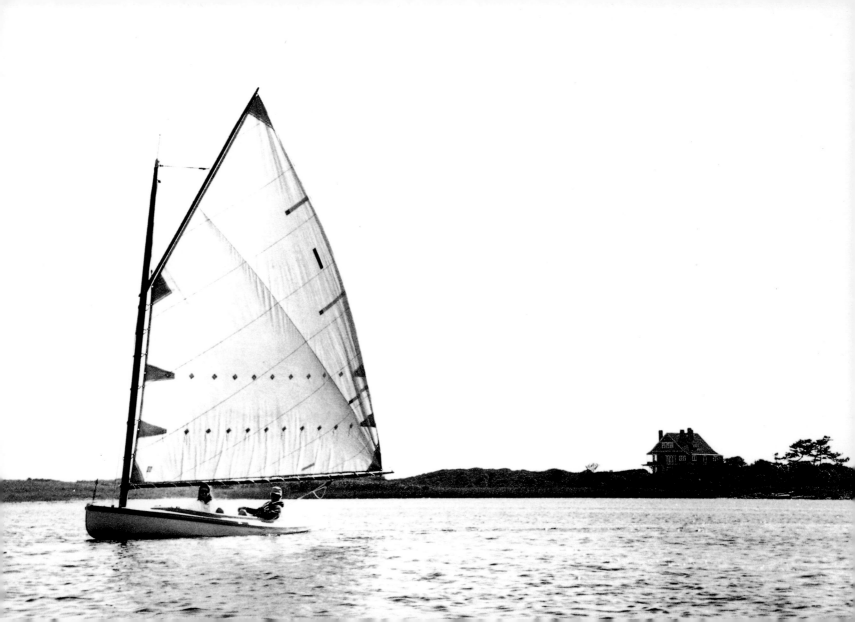

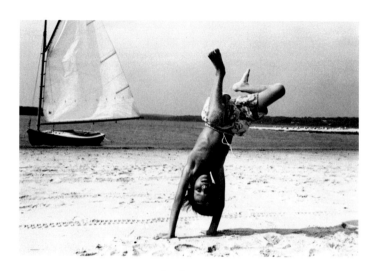

Look at me

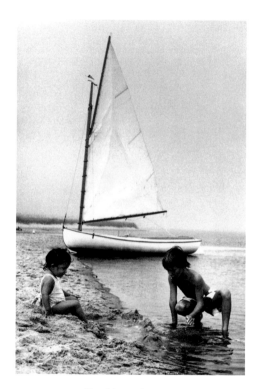

Catching minnows

Waterdance

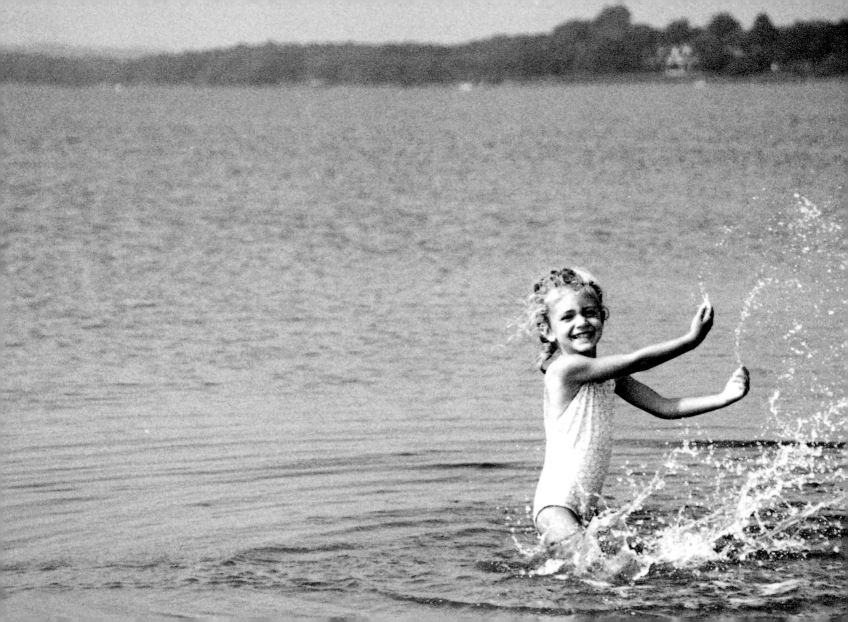

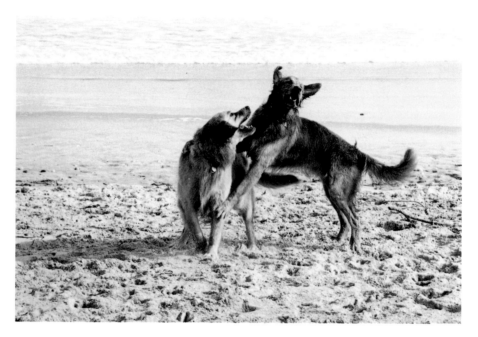

Romeo and Luna I

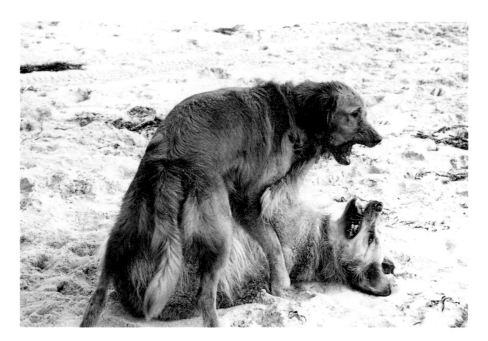

Romeo and Luna II

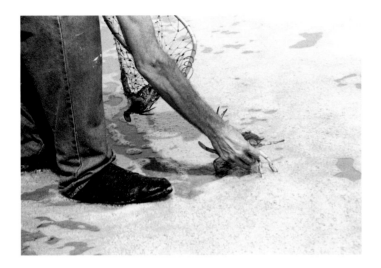

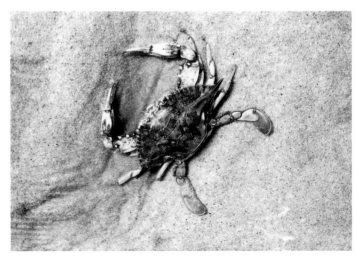

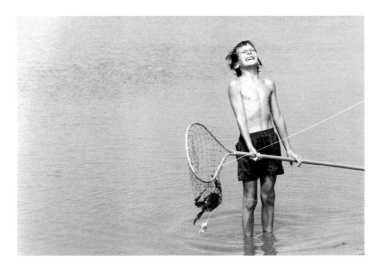

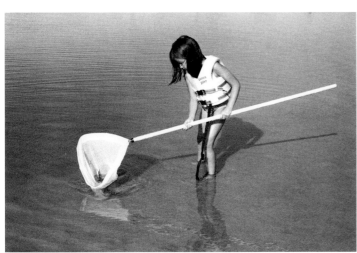

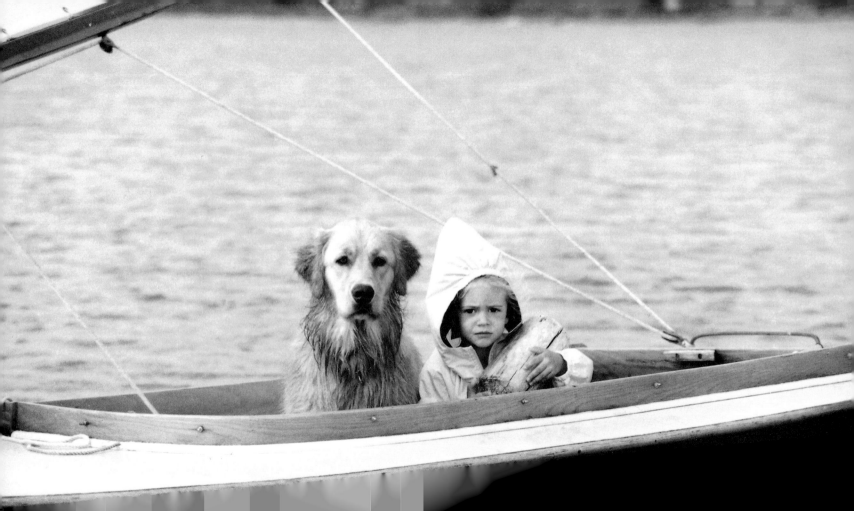

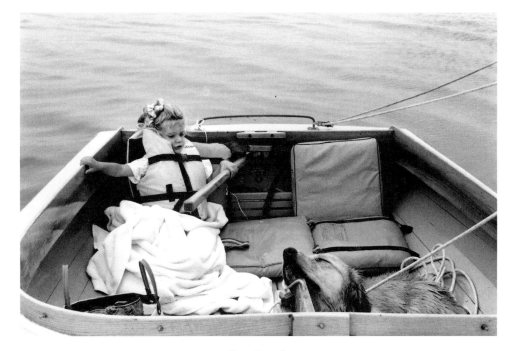

Best friends

The wary stare

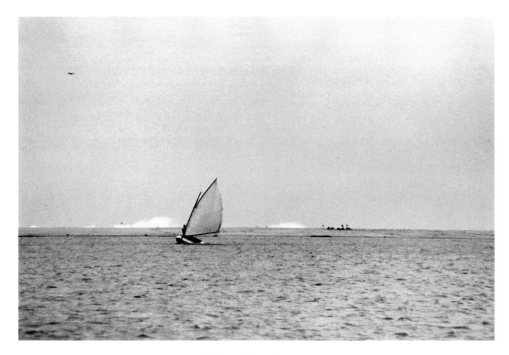

Sailing along the gut

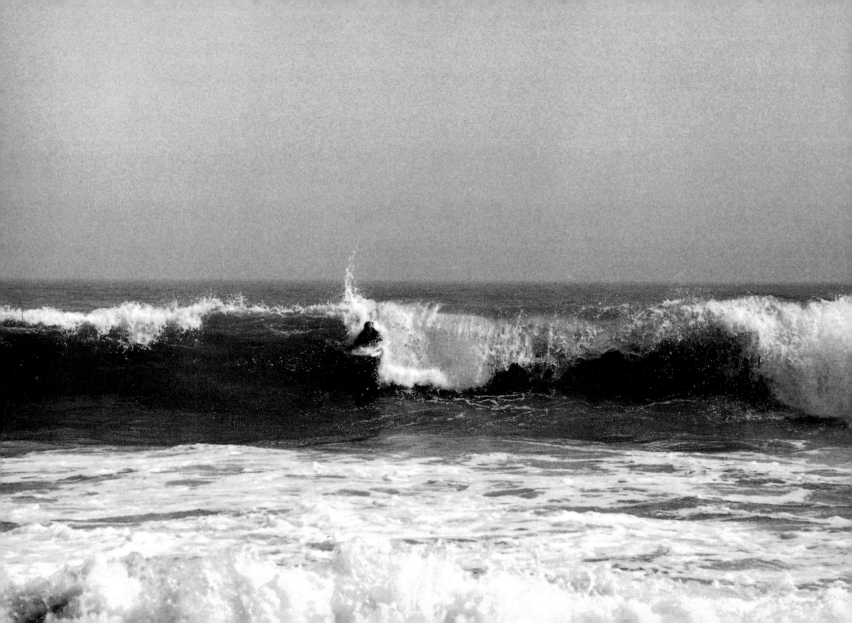

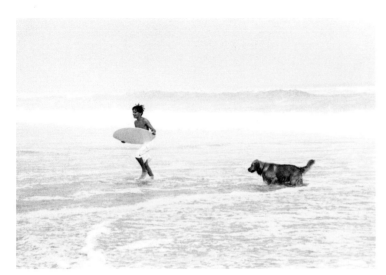

Skimboarding

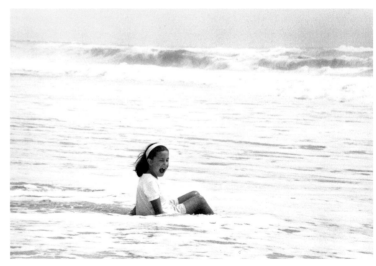

White water

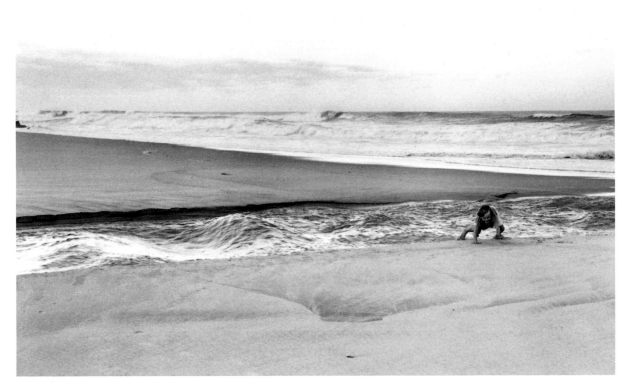

The gut after Hurricane Bob

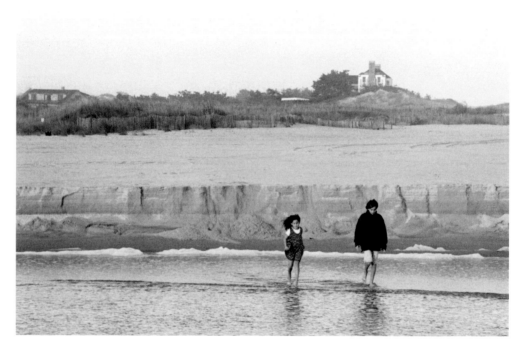

Crossing the open gut

Bliss

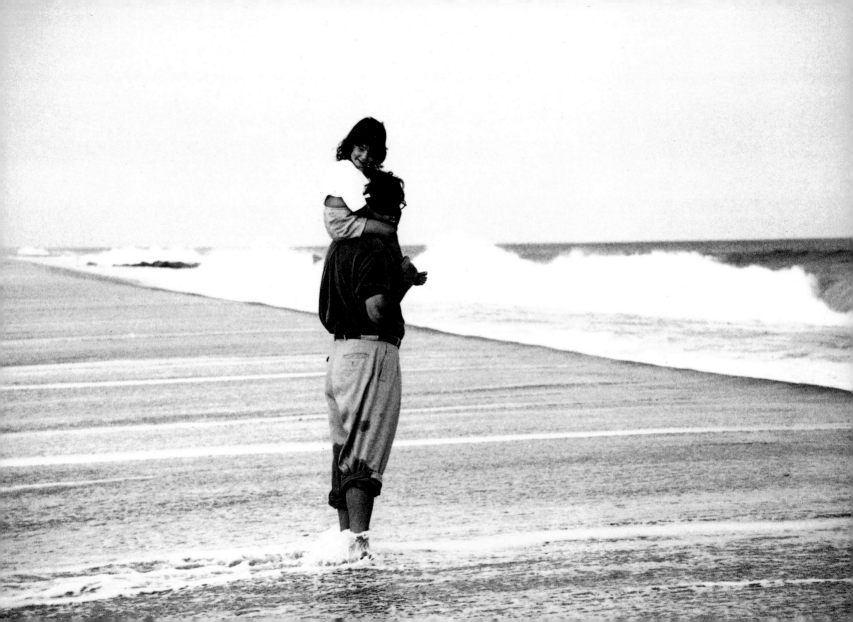

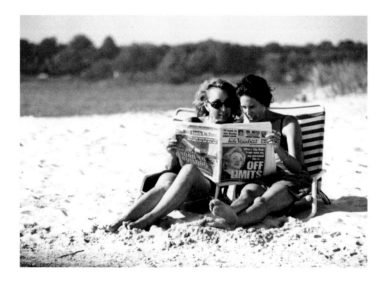

Gossip

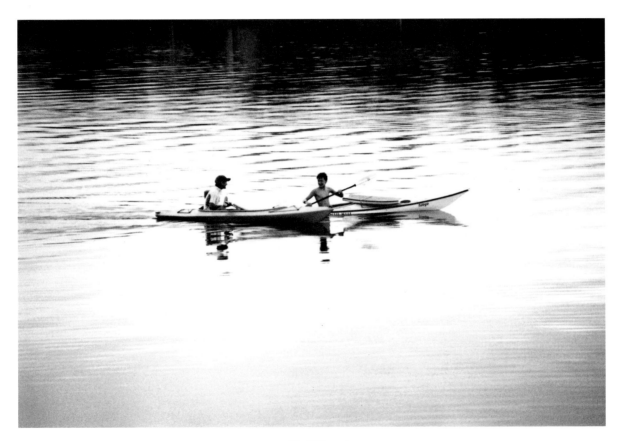

Paddling

Storm surge

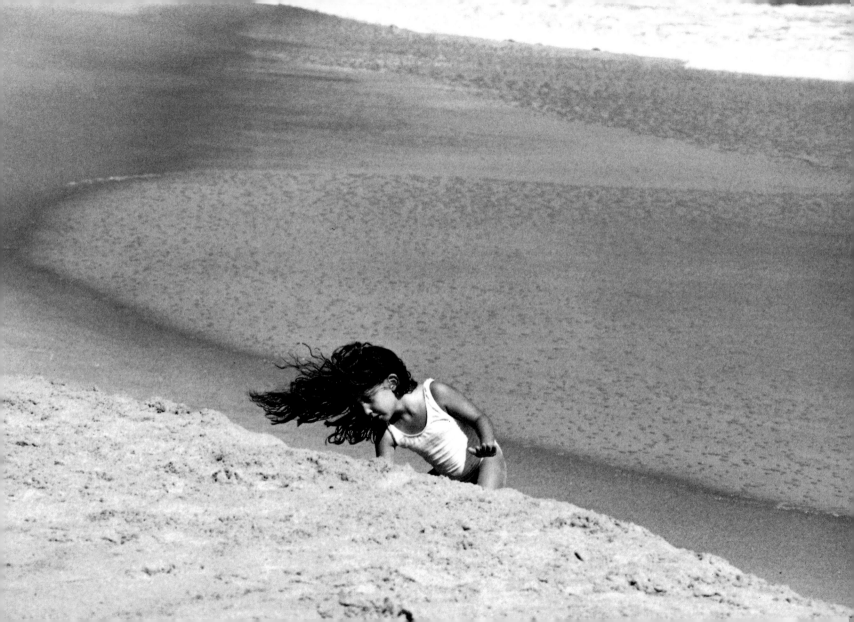

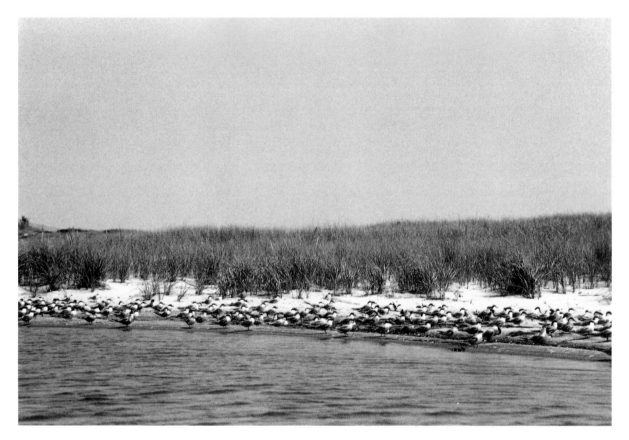

Piping plovers I

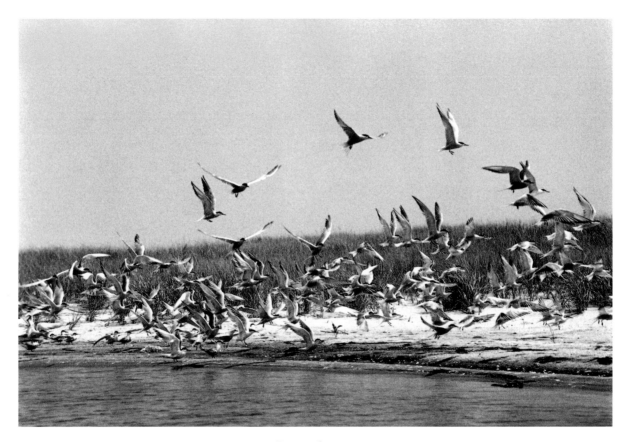

Piping plovers II

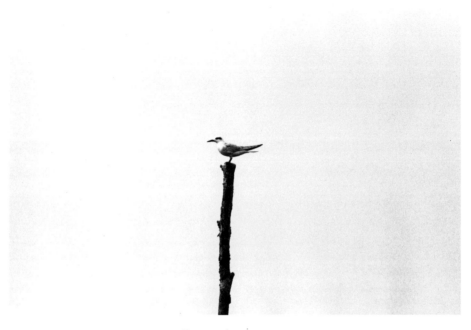

Piping plover at rest

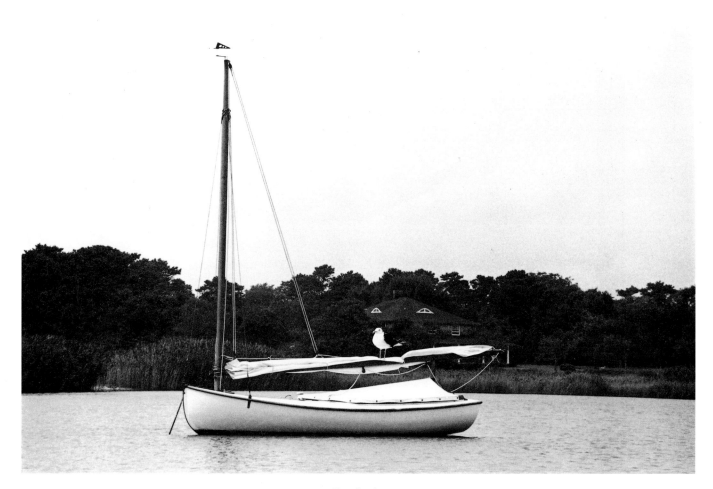

Dead calm

Hurricane Bob: the beginning

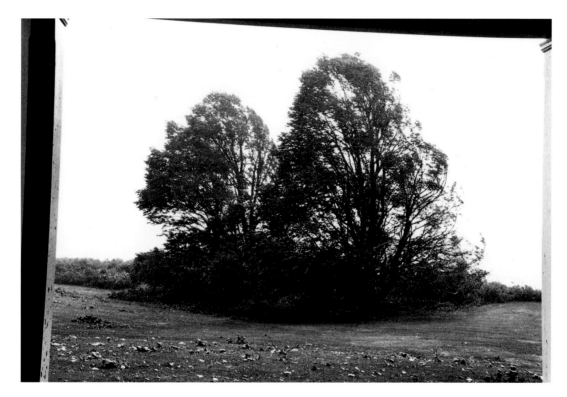

Hurricane Bob: the end

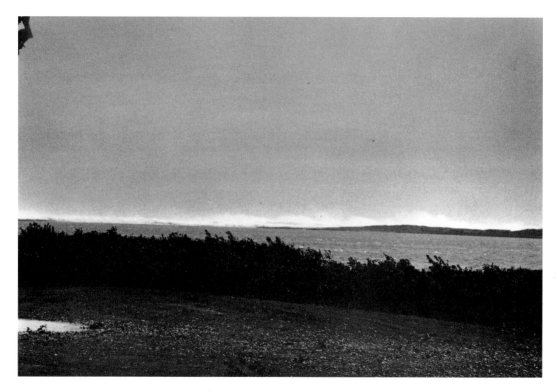

The gut during the storm

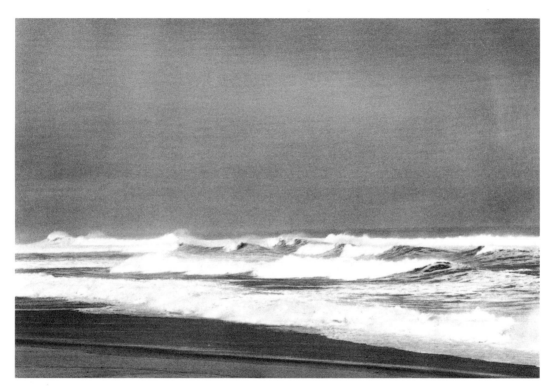

The ocean after the storm

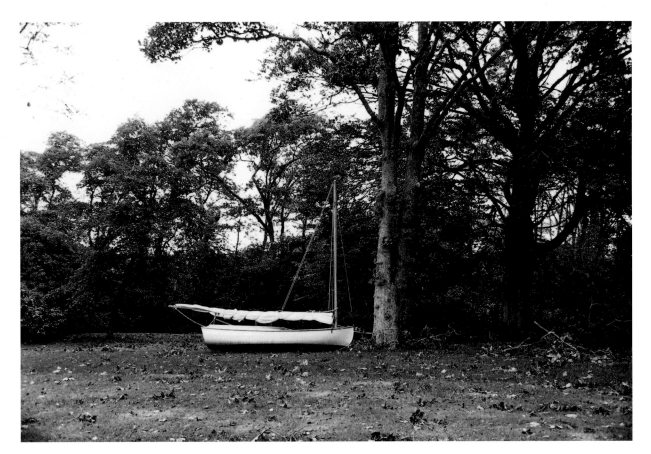

After Hurricane Bob

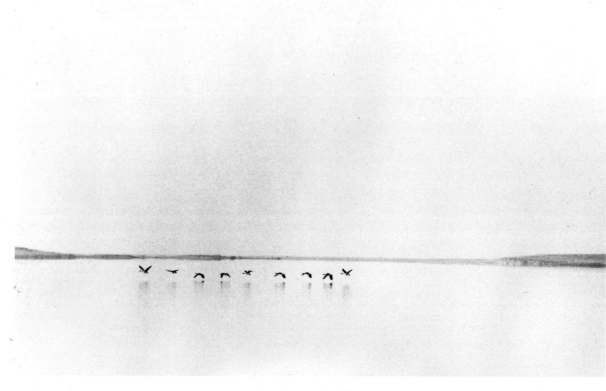

Canada geese landing

FALL

by Robert Benton

Labor day has come and gone. The traffic on Route 27 has begun to thin out, although the days are still mild and sunny with only the barest hint that summer is over.

A friend once told me that the Northeast has the most wretched springs in the world, but that nature makes up for it by giving us the most glorious fall in the United States. If that is true, then it is a bargain I am happy to live with. Dismal, chilly, damp spring days do hold the promise of the warm summer sun, but they do so against their will. Give me instead a long, glorious fall that slowly and gently eases us into winter. Who could ask for more?

By October, the canoes and kayaks have disappeared from Georgica Pond, along with the monarch butterflies and the snowy egrets. Fortunately, the blue heron that nests in the top of one of the pines remains. One by one, the beetle cats are pulled out of the water and stowed for the winter. That leaves only the baymen on the pond, along with one or two other hearty souls in single sculls. The baymen are setting out pots for eels, which they will ship off to Paris or Rome, where eels are considered a great delicacy. Just as I am happy to exchange a dreary spring day for an enchanted fall, I am delighted to trade our eels for French and Italian wine.

Looking at the single sculls, I am reminded of a neighbor of ours who owned one. He was a man named George Willis. With his wife Peg, he used to remain in their house overlooking the pond well into October.

Every morning at the first light of day, George would be out on the pond. On one of those mornings several years ago, when I was outside admiring the day, I saw George in his scull gliding across the water. I waved, held up my mug of coffee, and called out, "See what you are missing."

George stopped, waved back, and shook his head as if to say, "If you think I'd trade this pond and this scull and this morning for a cup of coffee, you've got to be crazy." Then he disappeared into the sun's glare.

Not long after, my wife and I got a phone call telling us that George Willis had died. A neighbor had found him in the middle of the pond, slumped over in his scull. Apparently he had suffered a heart attack and died instantly.

The Greek historian Herodotus quotes Solon, one of the founders of Athenian democracy, as saying, "Count no man fortunate until he is dead." I think to cross from this world to the next on Georgica Pond early on a clear autumn morning is an ending devoutly to be wished for.

Luna keeps watch

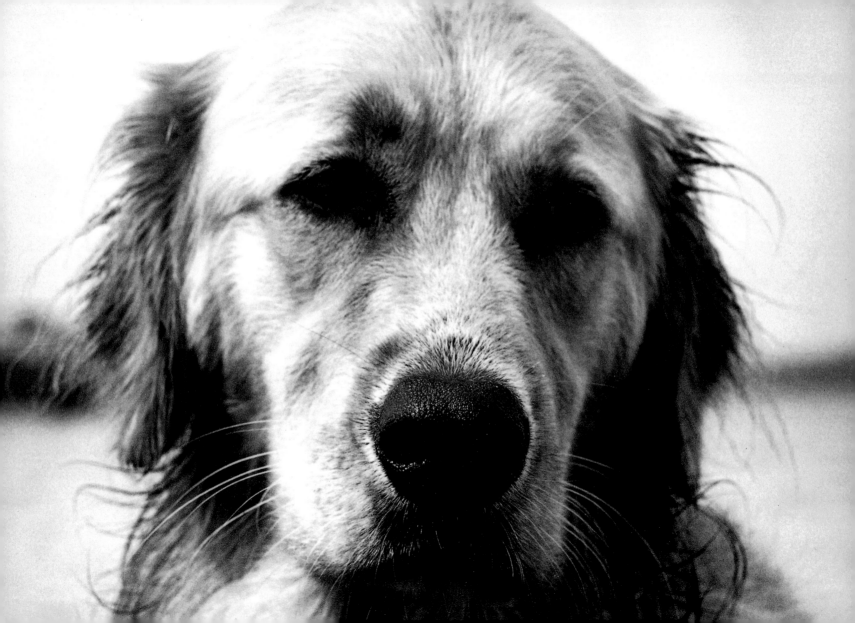

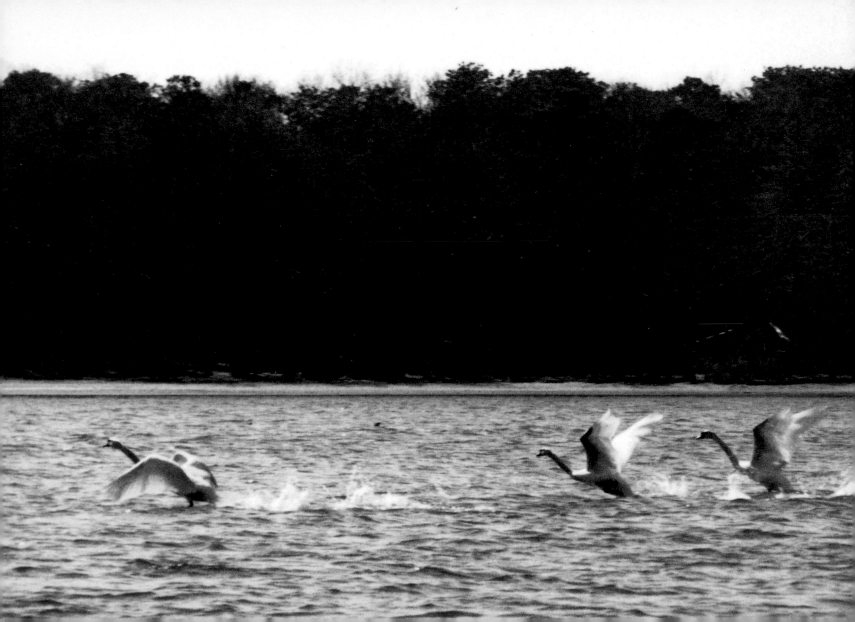

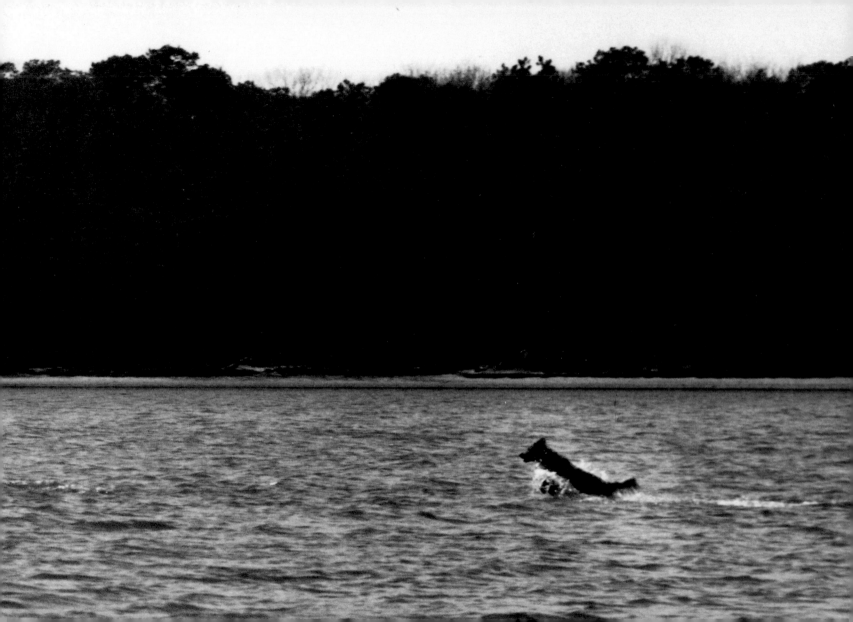

Previous page: fruitless pursuit

Early morning mist

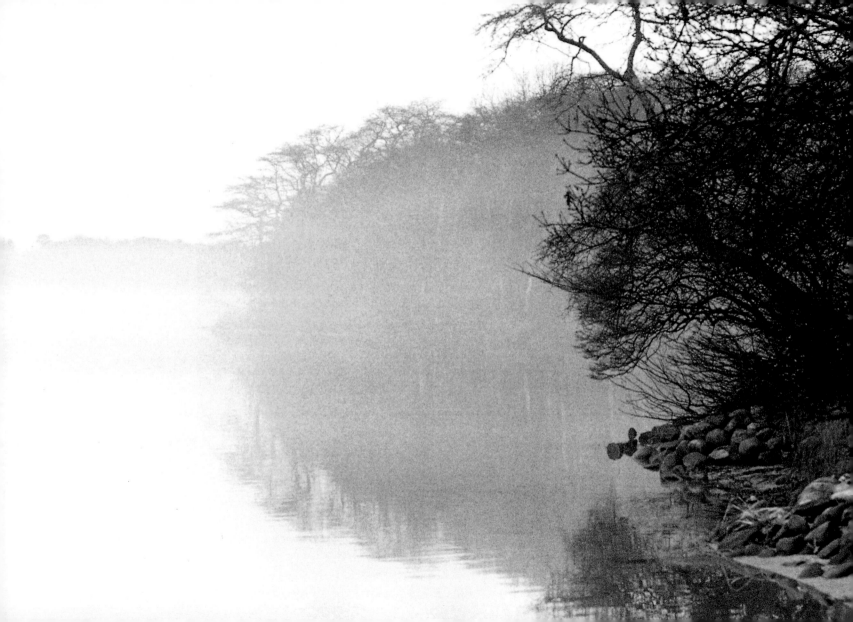

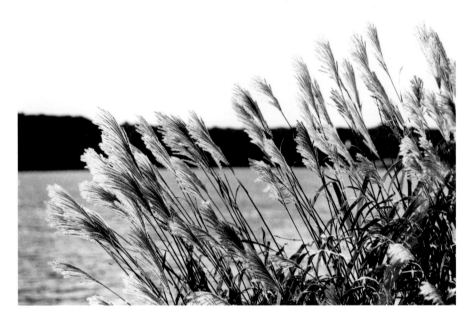

Feather reeds

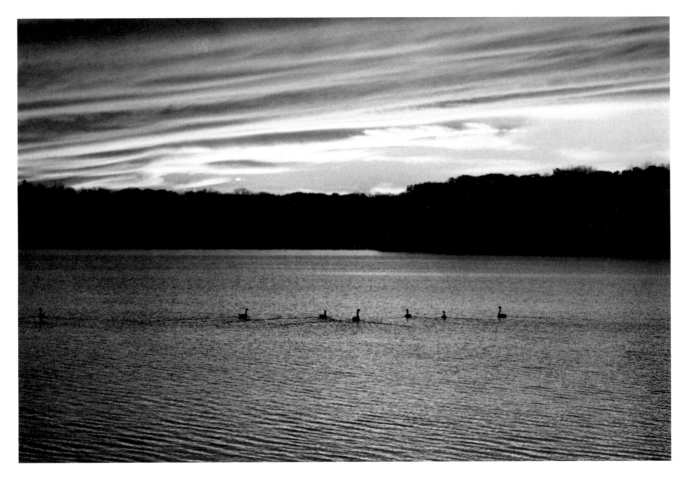

Sunset

Autumnal sands

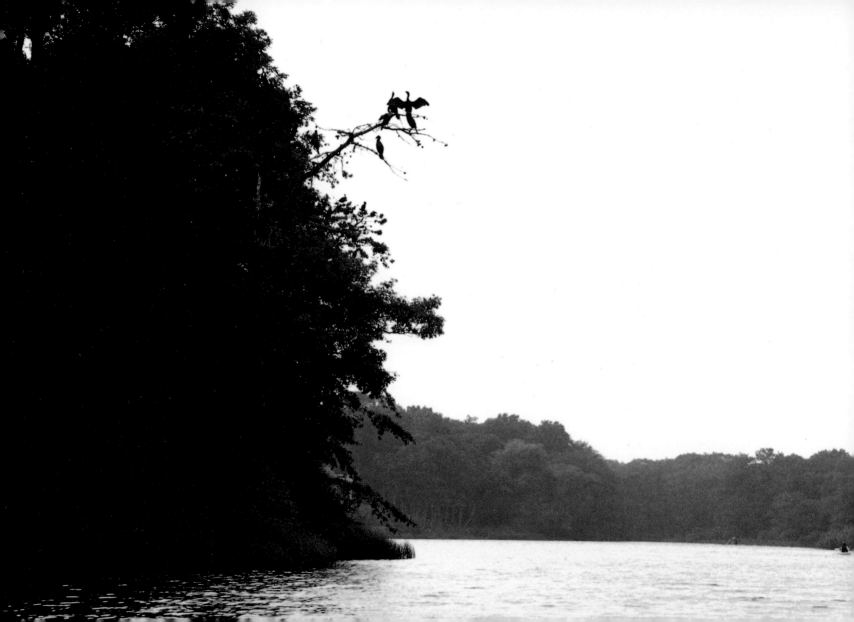

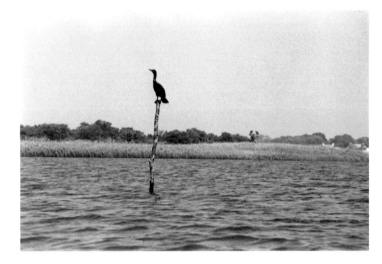

Pond with a view

Cormorant's perch

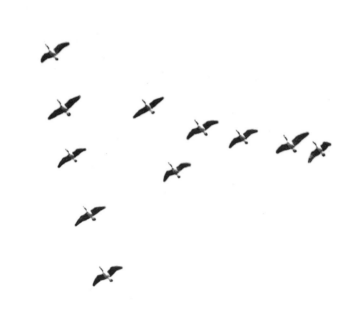

Previous page: Canada geese head south

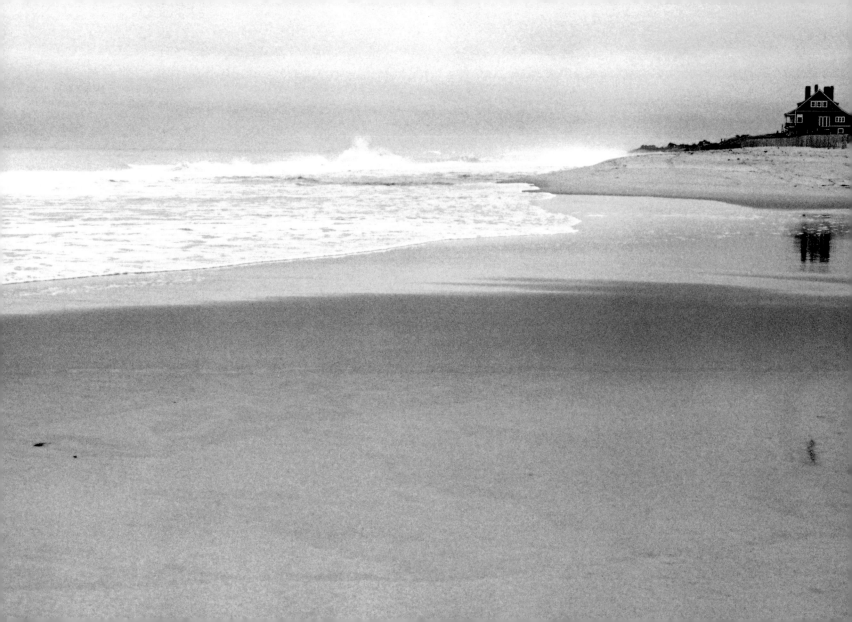

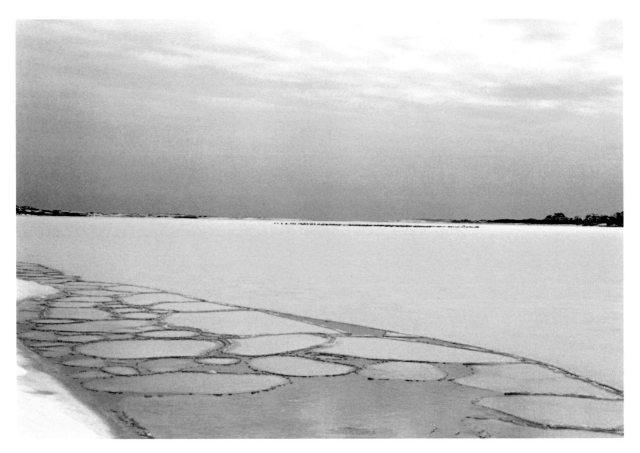

Ice formations

WINTER

by Kelly Klein

I HAVE LIVED ON GEORGICA POND for fourteen years. During those years, I have watched this exceptional pond go through its many—even daily—transformations.

The pond is drained of most of its water two, three, even four times a year. The resulting rise and fall of its waters reflect the pond's many seasonal moods. To me, however, the winter is its most vigorous and dramatic time. The water level is higher then than at any other time of year.

In winter, there are days when the wind blows in from a certain direction and the pond seems angry, all covered in waves and whitecaps. I watch the families of swans bobbing in the rough water, and I wonder how they manage to fight and swim against the small, choppy waves. Then, as the winter grows grayer and more desolate, the pond turns dark and forbidding. This is right before it begins to freeze.

When Georgica Pond freezes, it happens in one of two ways. The water may turn as transparent as a sheet of glass, shiny and slick, with marbleized designs running all across its surface. Or instead, it may freeze so deeply that it becomes a thick, white sheet of ice, thicker than a stone wall. It is a beautiful thing to see this large body of water become so dry and so solid.

Once, maybe ten years ago, when the winters were more extreme than they seem to be today, I saw a group of ice-sailing boards racing across the pond. I still remember clearly the amazing sound of the metal runners scraping the surface at speeds that I had no idea could be reached on ice! I immediately ran down with my camera to document these white-and-silver surfboards, so dramatic with their white sails on the white ice. I will never forget that moment on Georgica Pond. I don't know that I will ever see that sight again on this extraordinary pond.

After a snowstorm

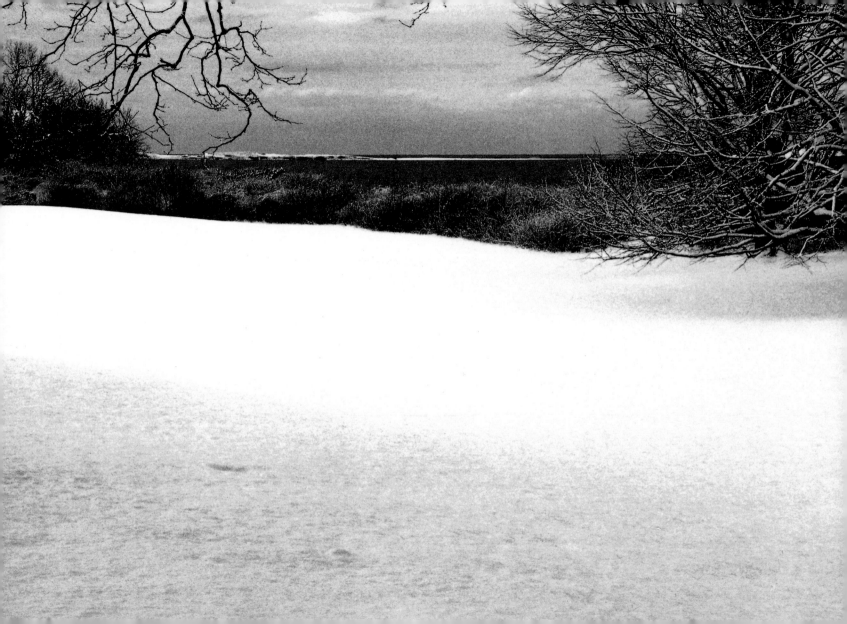

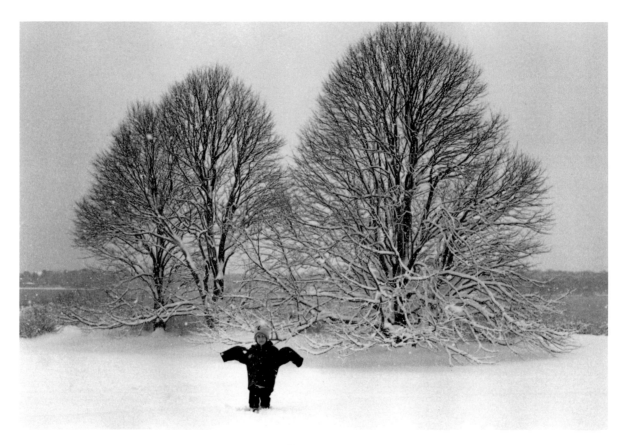

Scarecrow

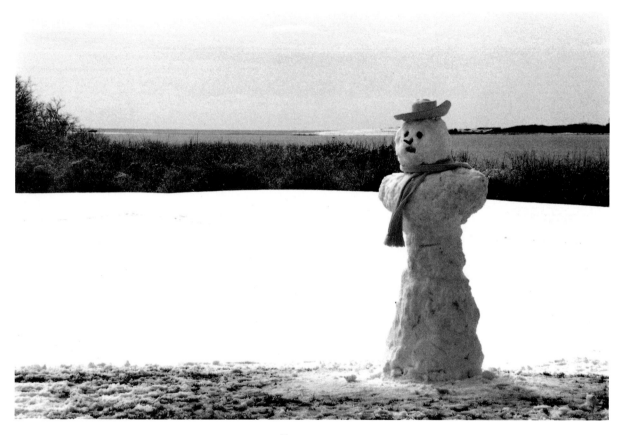

Snow person

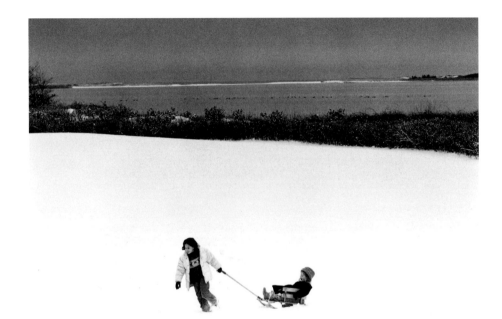

Sisters in the snow

Snow dance

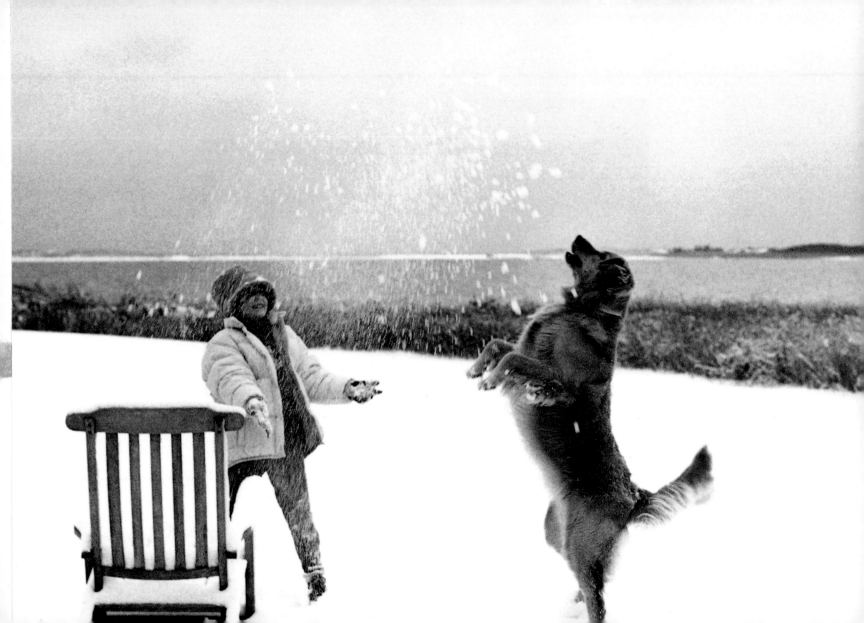

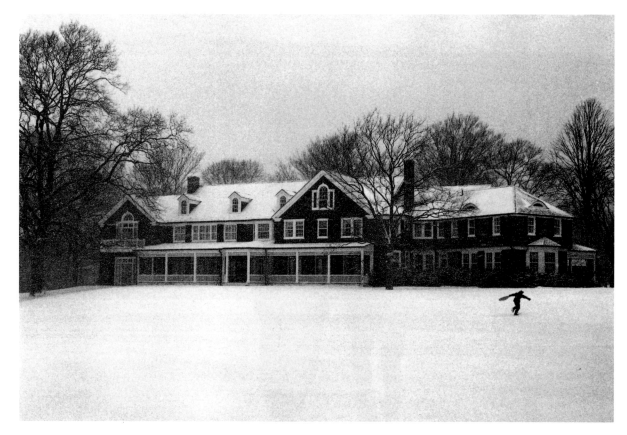

Briar Patch in the snow

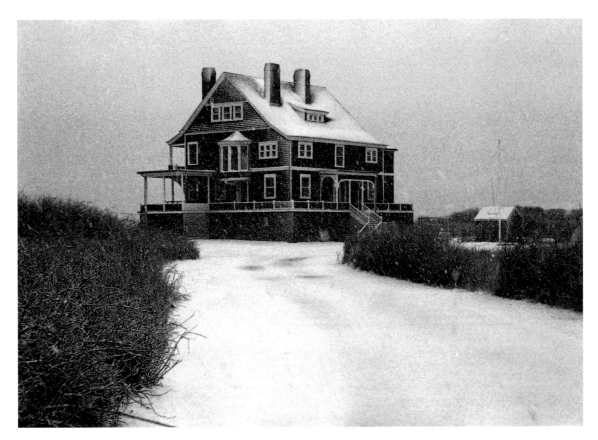

Kilkare in the snow

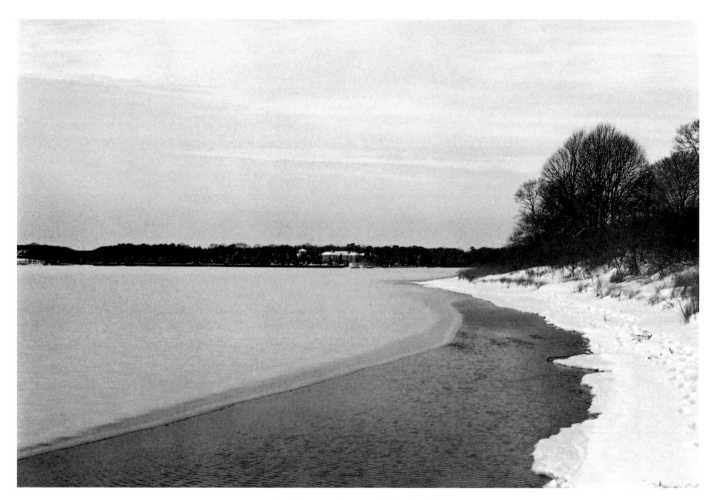

Looking north toward The Creeks

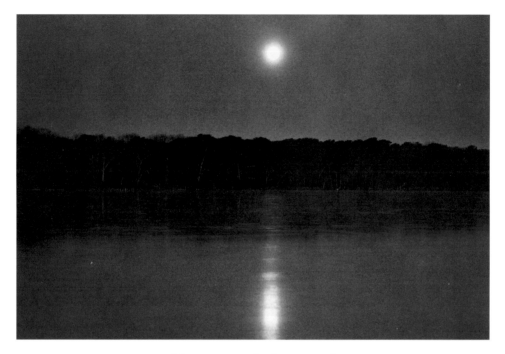

Moonset over the frozen pond

Three lindens near the pond

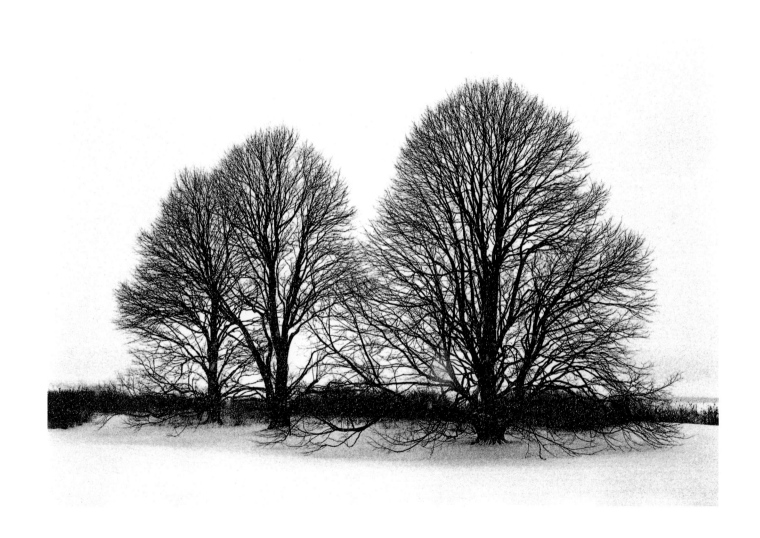

Three lindens in a snowstorm

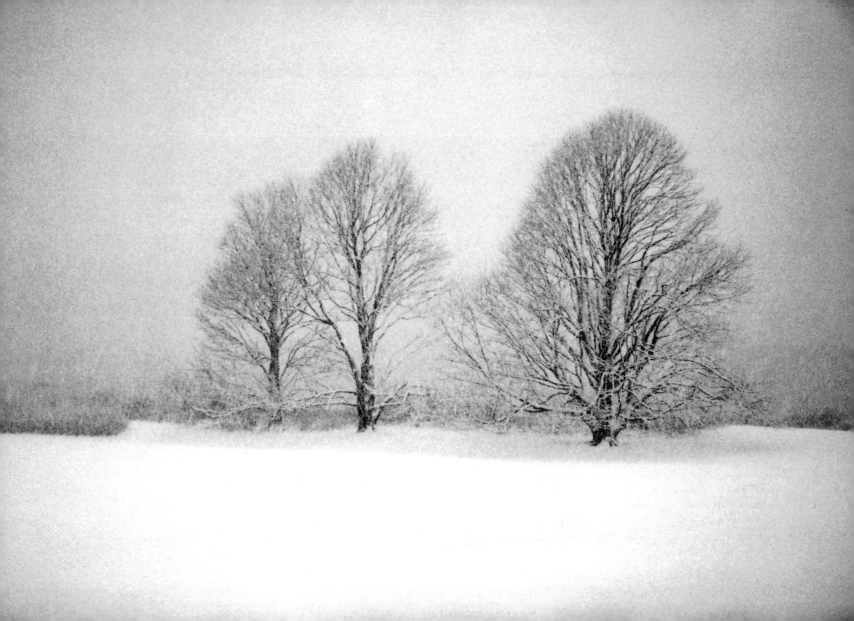

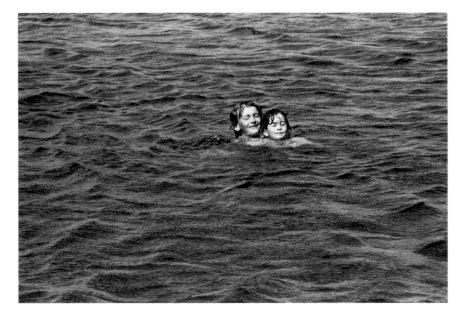

Brother and sister

ACKNOWLEDGMENTS

Many thanks to:

Lab One for printing all my photographs—one more time;

Robert Benton, Eleanore Kennedy, Kelly Klein, and Donald Petrie for writing the essays on the seasons;

again, Donald Petrie, with whom I consulted often;

Nicholas Callaway, Toshiya Masuda and Antoinette White for being a pleasure to work with;

Susan Calhoun for encouraging me over the years.

A portion of the proceeds from *Georgica Pond* will be donated to the South Fork–Shelter Island Chapter of The Nature Conservancy.

The Nature Conservancy is a private, international, nonprofit organization established in 1951 to preserve plants, animals, and natural communities that represent the diversity of life on Earth by protecting the lands and waters they need to survive. To date, the Conservancy and its more than one million members have been responsible for the protection of more than 11 million acres in the United States and Canada, and have helped through partnerships to preserve more than 60 million acres in Latin America, the Caribbean, the Pacific, and Asia.

The South Fork-Shelter Island Chapter, one of 60 Nature Conservancy offices in the United States, was formed in 1974 and now has 3,500 members. Working cooperatively with other conservation groups, businesses, and many levels of government, The Nature Conservancy has protected more than 30,000 acres on Long Island.

LUNA SWIMMING

CALLAWAY

64 Bedford Street
New York, New York 10014

Printed and typeset in Italy by Stamperia Valdonega
First Edition
10 9 8 7 6 5 4 3 2 1
Library of Congress Cataloging-in-Publication Data available.

ISBN 0-935112-47-2

Visit Callaway at www.callaway.com
Antoinette White, Senior Editor • Toshiya Masuda, Designer

HALF-TITLE PAGE: DRIPPING LUNA
FRONTISPIECE: STROLLING ALONG THE GUT IN HURRICANE SEASON
PAGE FOUR: FISHERMAN CHECKING CRAB TRAPS

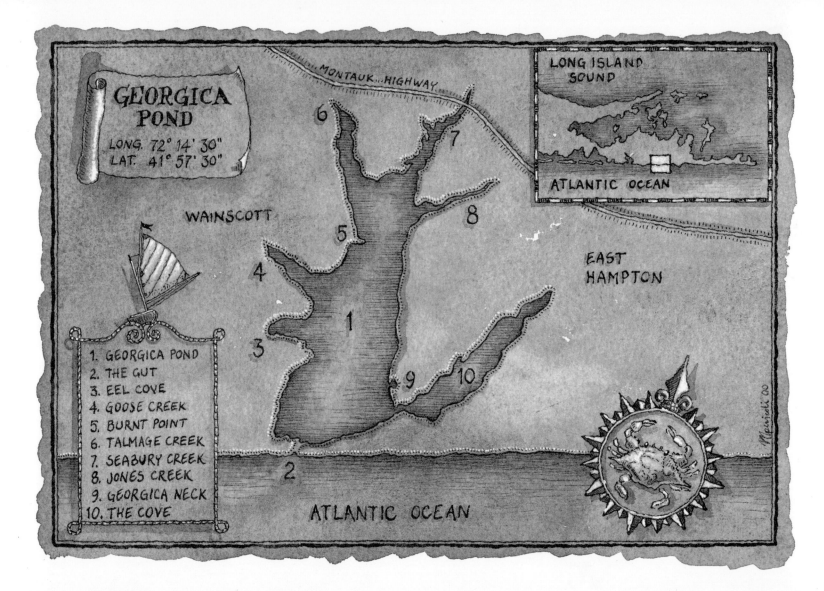

GEORGICA POND

LONG. 72° 14' 30"
LAT. 41° 57' 30"

MONTAUK HIGHWAY

WAINSCOTT

LONG ISLAND SOUND

ATLANTIC OCEAN

EAST HAMPTON

1. GEORGICA POND
2. THE GUT
3. EEL COVE
4. GOOSE CREEK
5. BURNT POINT
6. TALMAGE CREEK
7. SEABURY CREEK
8. JONES CREEK
9. GEORGICA NECK
10. THE COVE

ATLANTIC OCEAN